John
from Annie. O.P.
Christmas '86

a Moral AlphaBet
of Vice & Folly

Embellished with Nudes & other Exemplary Materials

by

Stan Washburn

Manufactured in the United States of America

Library of Congress Cataloging-in-Publication Data
Washburn, Stan.
 A moral alphabet of vice and folly.

 1. Washburn, Stan. 2. Alphabets in art. 3. Fables in
art. I. Title.
NC 139. W375A4 1986 818'.5402 86 - 17318
ISBN 0-87795-872-6

this book is for

Anne & John

INTRODUCTION

If you were to disregard the title of this book and judge from its thinness, you might expect its subject to be virtue rather than vice. And if you were to take its title and its thinness together you would have to assume that you were being cheated: the subject of vice and *folly* can scarcely be comprehended in so *few* pages.

But it is not the intention of this work to say the last word on the subject. This is not one of those fat and panoramic paperbacks that serves up the Whole Story.

Gentle reader, you hold in your hand a Slim Volume, undisguised and unashamed. It adheres to the rich tradition of Alphabets as miscellanies, as samplers of experience. The author does not pretend to a monograph on his subject; somewhat sadly, he does not even pretend to expertise. As little as he knows of vice, he knows still less of folly. From much observation of others, however, he has concluded that any consideration of the dilemmas of humankind should be undertaken in a sympathetic spirit. If the letter P is devoted to Philosophers, it is not intended that any patent of superiority should thereby be inferred by Prigs.

the Author

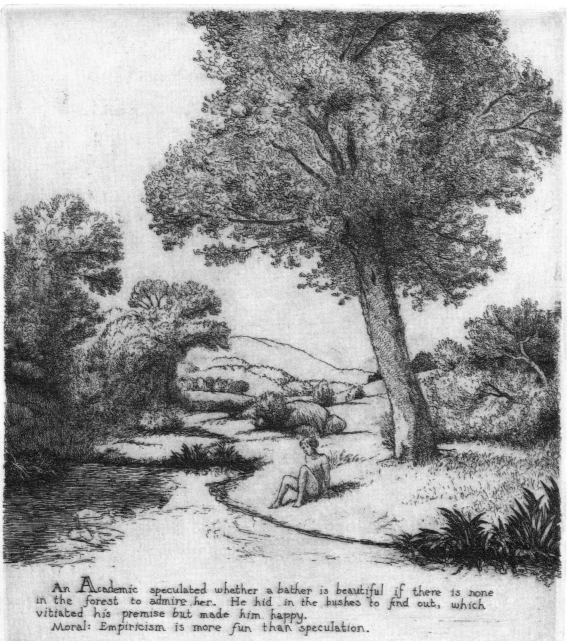

An Academic speculated whether a bather is beautiful if there is none
in the forest to admire her. He hid in the bushes to find out, which
vitiated his premise but made him happy.
Moral: Empiricism is more fun than speculation.

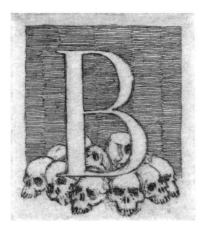

A **B**arbarian made a lot of money by way of pillage and extortion, until one day he was struck with remorse for his many enormities. He gave up looting and ravishing on the spot, and vowed to live in peace thereafter. But he did not refund the money.

Moral: Everyone has to live.

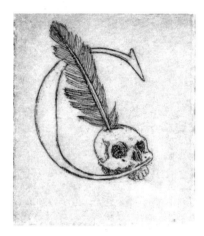

A Critic, after a life devoted to spoiling the pleasure of others, was astonished to find himself roasting in eternal hellfire. "Judge not, lest ye be Judged," giggled a passing fiend, and all Hades rocked with laughter at this wit.

Moral: When you have all Eternity to get through, it is a blessing to be among those who are easily amused.

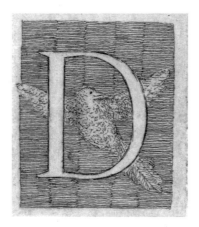

A Dove built a nest in the wreath of an Imperial bust. "If the Emperor were still alive he would skin me for this indignity," thought the dove. "It's a good thing for me that he's dead."

Moral: A tyrant should get his licks in while he can.

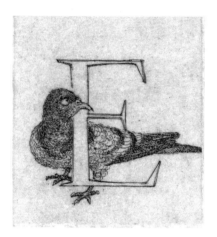

Eagle was rebuked for taking such
satisfaction in his magnificence. "All that distinguishes you
from the pigeon is your swiftness, your power, and your
terrible talons and beak," jibed his interlocutor.

"How right you are," replied the eagle.

Moral: It's fun to rub it in.

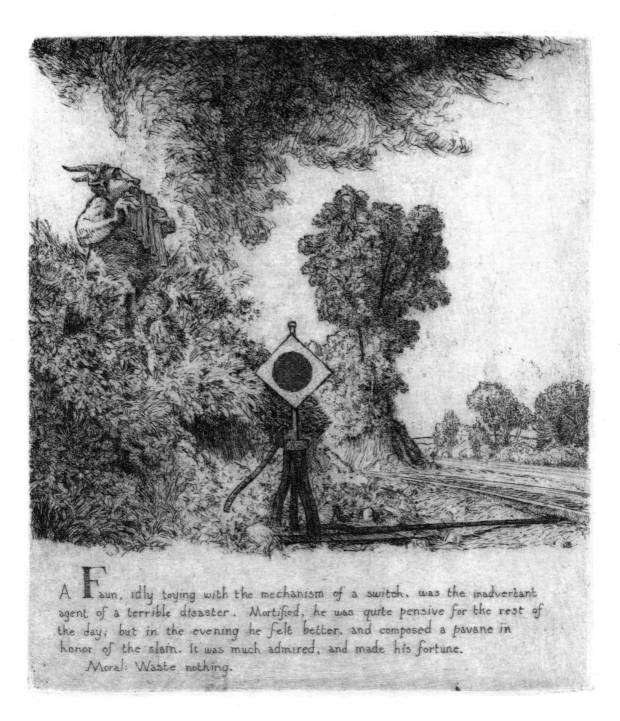

A Faun, idly toying with the mechanism of a switch, was the inadvertant agent of a terrible disaster. Mortified, he was quite pensive for the rest of the day; but in the evening he felt better, and composed a pavane in honor of the slain. It was much admired, and made his fortune.

Moral: Waste nothing.

The **G**races demanded of a fisherman that he judge which of them was
most beautiful. His honest answer, "Yer none on ye a patch on my Griselda,"
was not what they wanted to hear, and they blasted him with lightning,
and his Griselda with him.

Moral: An honest heart beats longest in a tactful bosom.

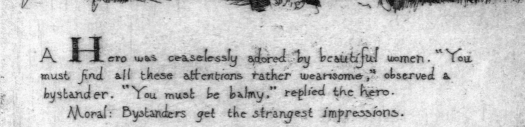

A Hero was ceaselessly adored by beautiful women. "You must find all these attentions rather wearisome," observed a bystander. "You must be balmy," replied the hero.

Moral: Bystanders get the strangest impressions.

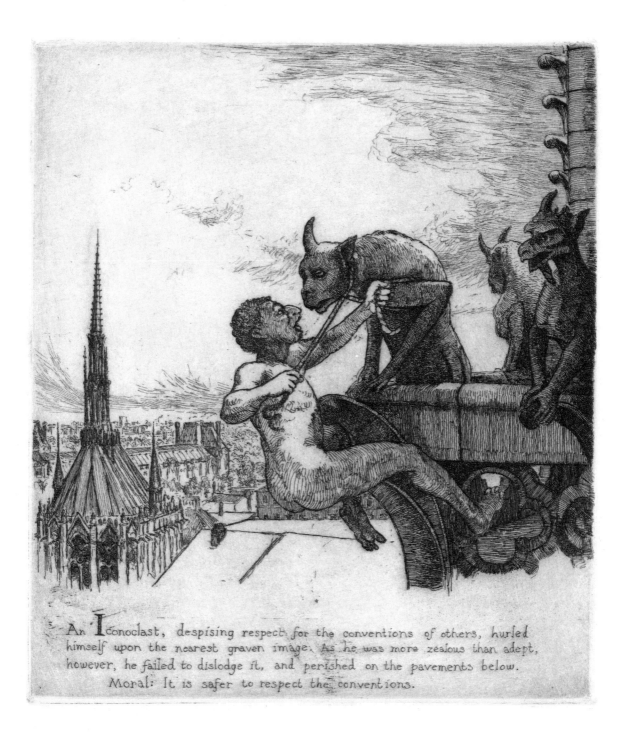

An Iconoclast, despising respect for the conventions of others, hurled himself upon the nearest graven image. As he was more zealous than adept, however, he failed to dislodge it, and perished on the pavements below.

Moral: It is safer to respect the conventions.

A newly installed Judge was presented with a chair upholstered in
the hide of his corrupt predecessor.

"Let this chair remind you to be honest," intoned the King.

"It will certainly remind me to be discreet," joked the judge, who was
presently made into a matching footstool.

Moral: the mot juste caps the bon mot.

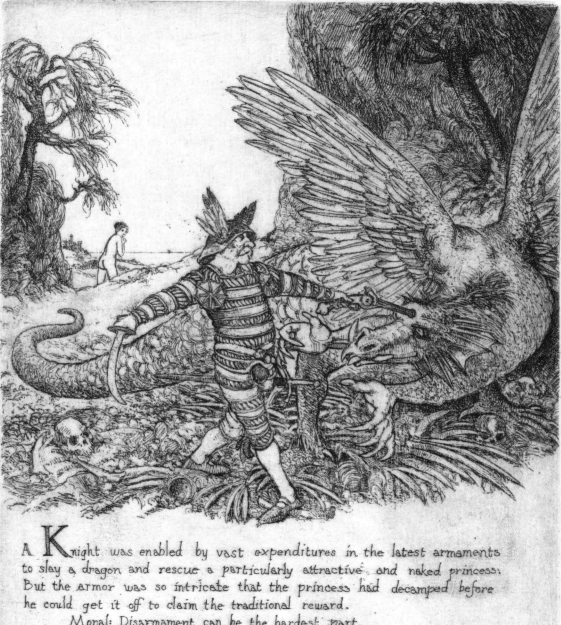

A **K**night was enabled by vast expenditures in the latest armaments to slay a dragon and rescue a particularly attractive and naked princess. But the armor was so intricate that the princess had decamped before he could get it off to claim the traditional reward.

Moral: Disarmament can be the hardest part.

A Lawyer, newly arrived in Hell, discovered that his punishment was to declaim endlessly to a jury of imbeciles and a sleeping judge. "Except for the food," he thought. "I would never have known I had died."

Moral: Look around you.

An artists' Model was much importuned by lechers.
She began bringing her imposing dog to work, but then the lecher
trade dropped off so sharply that her livelihood was endangered.
Moral: Self-employment is full of pitfalls.

A Nonconformist divine, doubting in his age the fanciful heresies of his youth, and fearing the everlasting torments which might hereafter await him, funked. He became an atheist, reasoning that if religion were tripe, deviation would not matter. Thus he died at peace. Moral: Comfort is where you find it.

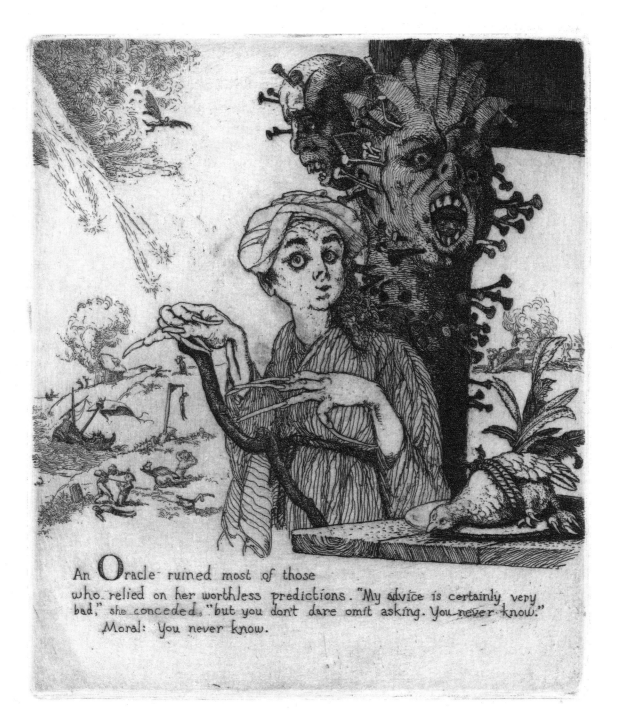

An Oracle ruined most of those
who relied on her worthless predictions. "My advice is certainly very
bad," she conceded, "but you don't dare omit asking. You never know."
Moral: You never know.

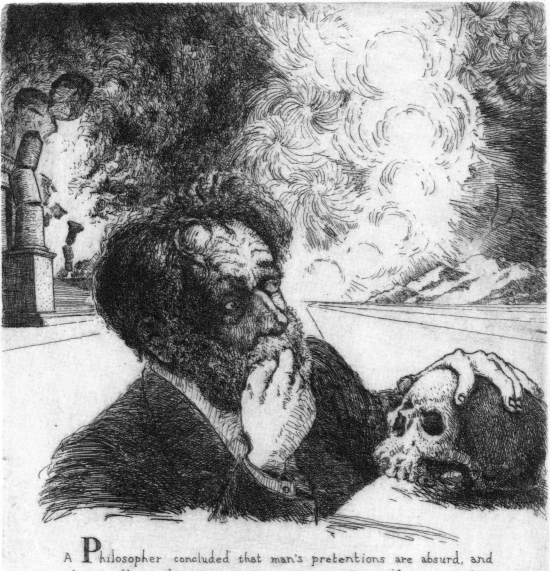

A Philosopher concluded that man's pretentions are absurd, and
that wordly endeavor is without purpose. So assiduous were his
ruminations on this insight that he neglected to publish, and in
due course he perished. Moral: Publish.

A Quail thought himself pretty gaudy. Indeed, vanity so engrossed him that he failed to notice that other cocks were enjoying the hens in his stead. Without progeny, he declined at last into a lonely dotage, at full leasure to repent his inattention to duty.

Moral: We have our looks for a reason.

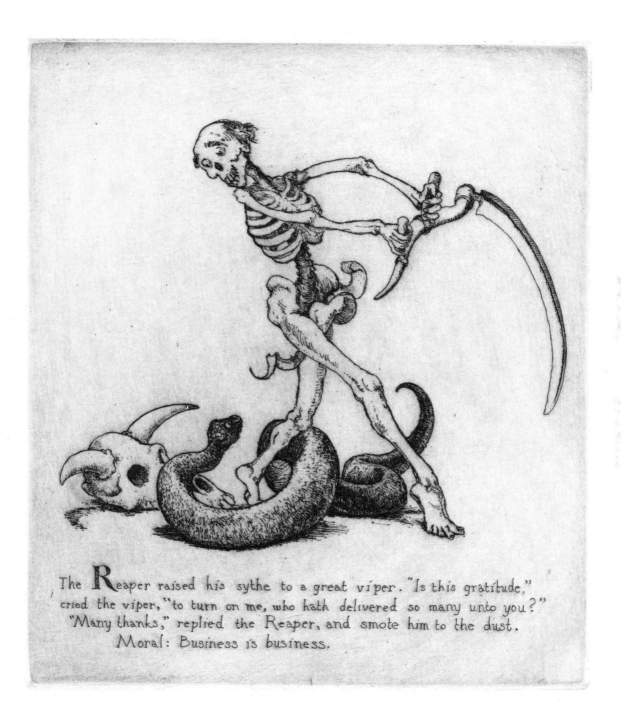

The Reaper raised his sythe to a great viper. "Is this gratitude," cried the viper, "to turn on me, who hath delivered so many unto you?" "Many thanks," replied the Reaper, and smote him to the dust.

Moral: Business is business.

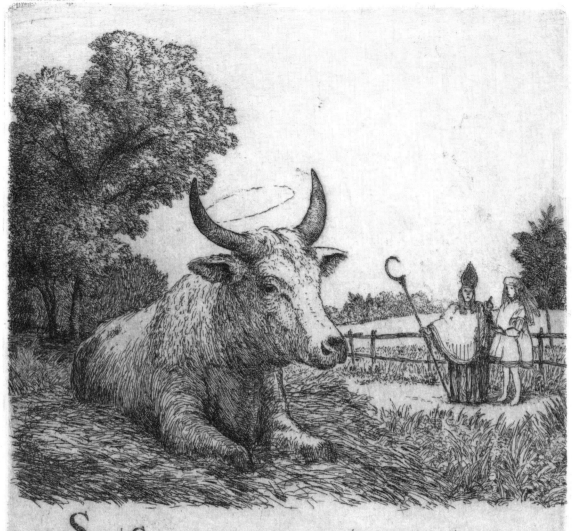

A Sacred Cow was so venerated that nobody dared milk her. This was very painful for the cow. Everyone felt it keenly, but clergy and laity were helpless alike — the beast did not respond to spiritual consolation, and the obvious secular measures savored of irreligion.

Moral: For the pious, nothing is simple.

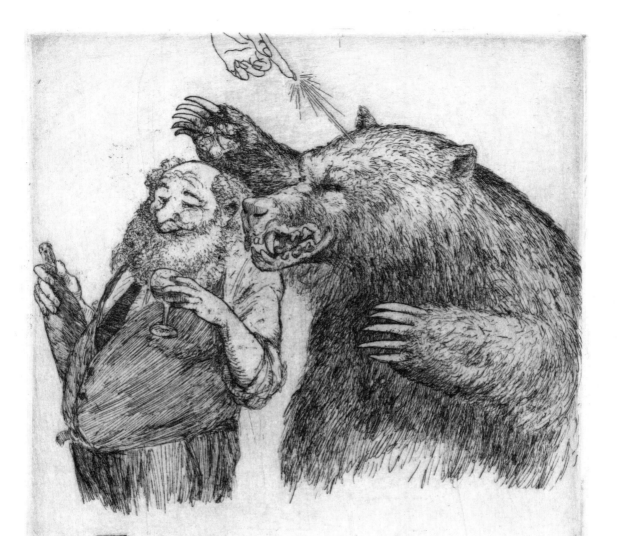

A Taxidermist stuffed a bear with such brio that he cried aloud,
"I _love_ it!" A passing goddess, imperfectly understanding, but
wishing to be responsive, kindly brought the beast to life. It
consumed the artisan forthwith.
 Moral: Say what you mean.

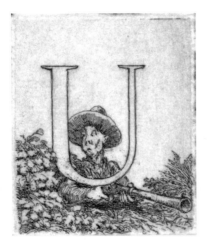

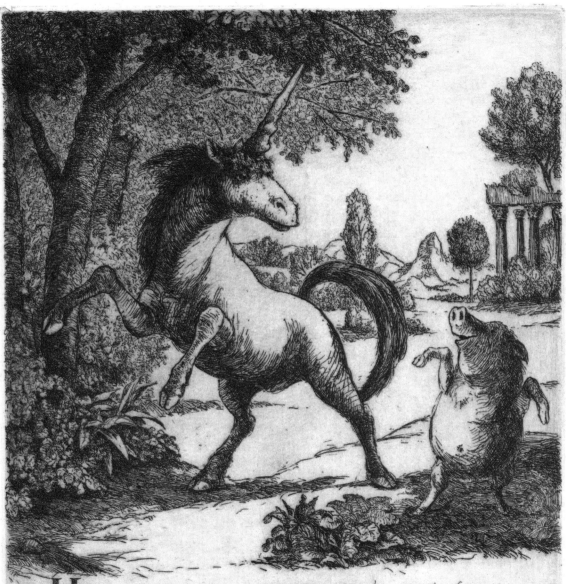

The Unicorn is superior to the swine in every particular, except, of course, that it cannot resist the blandishments of virgins, and thus is easily captured. The swine, being less fastidious, is more elusive.

Moral: Daintiness doesn't come cheap.

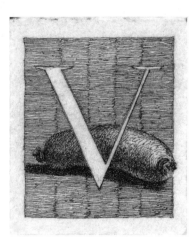

A Vegetarian was smitten with desire for a fat and greasy sausage. His longing was intense, his will shaken. But happily, wine could fortify him, and he raised this rampart of principle so high that he could set temptation at defiance.

Moral: Dutch courage is better than none.

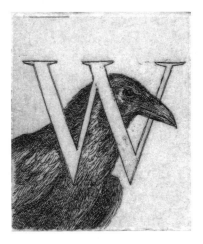

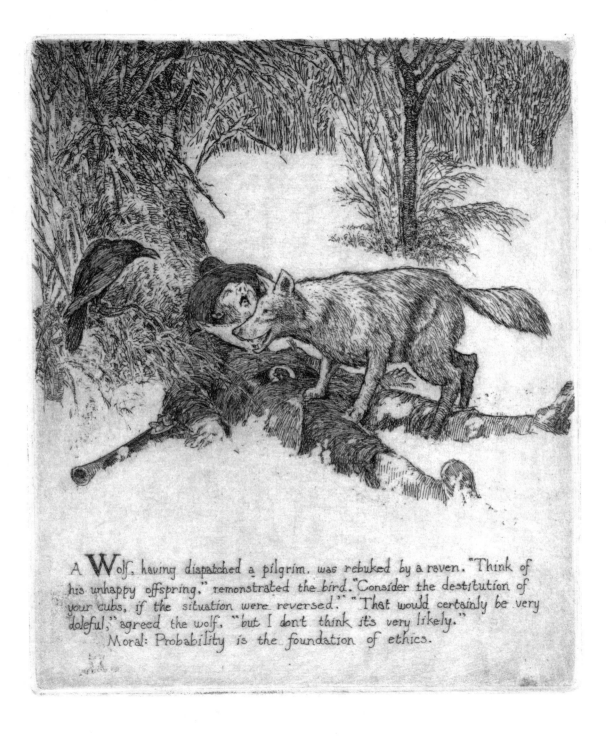

A Wolf, having dispatched a pilgrim, was rebuked by a raven. "Think of his unhappy offspring," remonstrated the bird. "Consider the destitution of your cubs, if the situation were reversed." "That would certainly be very doleful," agreed the wolf, "but I don't think it's very likely."

Moral: Probability is the foundation of ethics.

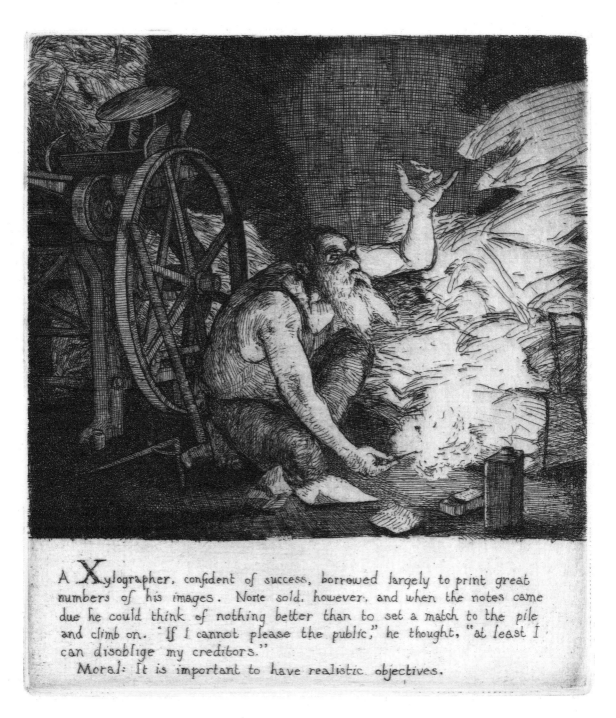

A **X**ylographer, confident of success, borrowed largely to print great numbers of his images. None sold, however, and when the notes came due he could think of nothing better than to set a match to the pile and climb on. "If I cannot please the public," he thought, "at least I can disoblige my creditors."

Moral: It is important to have realistic objectives.

A Youth received an annuity from his doting aunt, but it was not a large one. "Alas, my nephew is not well endowed," she lamented to the young ladies of the town, who received this intelligence with unbridled hilarity, and afterwards avoided him.
Moral: Never discuss finances.

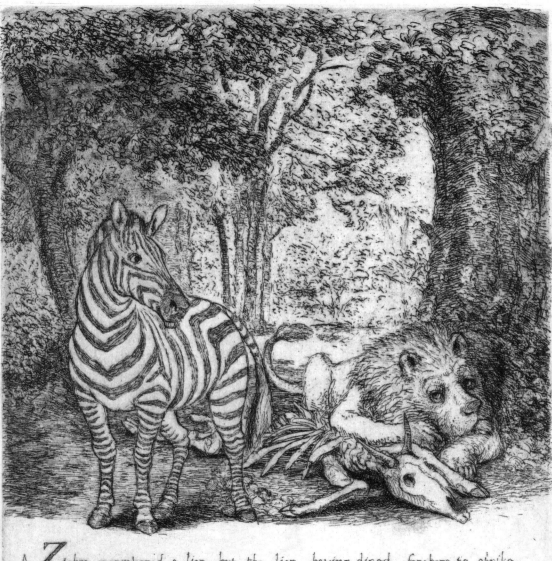

A Zebra encountered a lion, but the lion, having dined, forebore to strike. "To think," cried the zebra ecstatically, "that I might have been carrion at this moment. Instead, I live! I live!" "There's always tomorrow," yawned the lion.

Moral: There's always tomorrow.

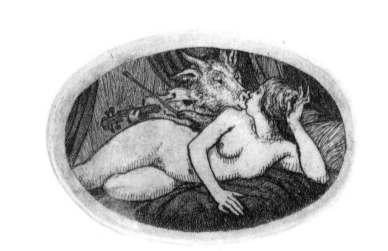